RSA:NC

RSA NEW CONTEMPORARIES

19 MARCH – 13 APRIL 2011

The Royal Scottish Academy has a proud tradition of promoting excellence in contemporary art in Scotland. Led by eminent artists and architects it supports the creation, understanding and enjoyment of the visual arts through exhibitions, artist opportunities and related educational talks and events. Re-establishing itself as a leading organisation for the visual arts in Scotland, it has successfully garnered a reputation for the strength of its engaging and diverse exhibitions and the fantastic opportunities it offers both established and emerging artists.

Published for the exhibition at
The Royal Scottish Academy of Art & Architecture
The Mound, Edinburgh, Scotland, EH2 2EL
www.royalscottishacademy.org

CONTE

INTRODUCTION

ALEXANDER MOFFAT RSA, EXHIBITION CONVENOR

When the RSA launched New Contemporaries three years ago the primary aim was to initiate an exhibition which would set new standards in promoting and supporting emerging artists and architects. Our intentions were to select the most ambitious work from the most talented undegraduate students and by doing so, create a platform for excellence that would help to develop professionalism in graduating students. To achieve this would require the Academy to establish a strong curatorial direction while simultaneously entering into a new partnership with the Art Schools. The task of the selectors, comprising academicians and art school staff was to identify quality, talent and excellence. We believed that bringing together the work of young artists from the five Scottish degree awarding Schools to form a site for dialogue and debate would both compliment the important role the Schools play and enhance the status of contemporary art in Scotland. Above all, we hoped that by participating in New Contemporaries, those young artists and architects might go on to enjoy a life-long relationship with the Academy.

The difficulties involved in moving outside the realm of the Art School into the professional art world should not be underestimated. A big public exhibition of a young artist's work in the RSA galleries assumes a very special significance. For the first time the individual achievements of each artist are made accessible to a wide audience. Inevitably new readings and evaluations will be attached to the works on show and the future prospects of the artist will be dramatically transformed.

The art of our time takes on many roles and many appearances and the different art forms - painting, sculpture, printmaking, installation, film, photography, performance, etc that now constitute the reality of degree shows across the western world (and actually have done for the past half century) have their own idioms and properties and New Contemporaries reflects the wide range of creative activity currently in existence.

All meaningful art has its roots in the local and this too, is embedded in many of the works included in the exhibition. All attempts to standardise the Fine Art degree have been resisted and the distinct identities of the Scottish Art Schools remain in place despite the demise of the artist/teacher over the past two decades. It might be appropriate at this present time to acknowledge it is precisely because of the commitment and dedication of their artist/teachers, that the work of the young artists in New Contemporaries is able to emerge directly from the exploration of a practical discipline, and that when allied to a questing and courageous intelligence is further able to give renewed vigour to that potent dream of which all art speaks.

Descriptions of the state of the art world vary enormously as to positive and negative possibilities: there are ongoing arguments as to what aspects of art-making are progressive and forward looking, or regressive and backward looking. Even the very nature of how the art world operates and what it signifies are open to question. Anyone who claims to understand what it all means only dares to make such a claim over a relatively short period of time. This is of course all part of the new/old modernist, or call it if you wish, post modernist (another strategy of displacement) struggle for definition in the amazingly mobile (except for those who think it is immobile) contemporary world.

Young artists are under siege today. Continuously assailed by information coming from all directions, all of the time, can be a confusing experience. Making choices which will determine a course of action, establishing a position, or working out a form of resistance, all become more and more problematic. In order to interpret the world, one must first understand it. Accordingly, I hope the exhibition will become a forum where issues are voiced and new energies emerge; it is important to demonstrate that in Scotland today, the work of young artists does matter.

To work effectively within the context of contemporary art requires an understanding of the agencies which promote or inhibit social and cultural change across time. Artists proceed gradually by absorbing the achievements of their predecessors in order to come to an understanding of their own historical position. To sustain a life-long career as an artist and to contribute to the advancement of creativity, knowledge and understanding by confronting the dilemmas of a changing world remains the primary goal - the only one worth having.

EXHIBIT

SELECTED FROM THE 2010 DEGREE SHOWS

FINE ART DUNCAN OF JORDANSTONE COLLEGE OF ART & DESIGN

Joss Allen
Kimberly Bartsch
Sinéad Bracken
Fiona Gordon
Charlene Noble
Lyndsey Redford
Vicki Ross
Mary Somerville
Kimberley Stewart
Lisa Ure
Jan Williamson
Colin Wilson

FINE ART EDINBURGH COLLEGE OF ART

Anne Benson
Jessie Buchanan
Laura Byrne
Joseph Calleja
Arwen Duncan
Shaun Fagan
Alex Gibbs
Geri Loup Nolan
Calum McClure
Francesca Miller
Ruth A Nicol
Jamie Robinson
Gordon Simpson
Kim Wilson

FINE ART GLASGOW SCHOOL OF ART

Martin Bech-Ravn
Naomi Bell
Ben Crawshaw
Diane Dawson
Alyssa Evans
Hazel Gore
Hannah Hewins
Lauren Iredale
Gabrielle Lockwood Estrin
Richard Martin
Paul McDonald
Andrew Nice
Shaun O'Donnell
Timothy Pulleyn
Alex Thornton
Lyndsey Wardrop
Mary Wintour

FINE ART GRAY'S SCHOOL OF ART

Laura Campbell
Susan Gauld
Anna Geerdes
Lyndsey Gilmour
Stephen Kavanagh
Alexander Storey Gordon
Stephen Thorpe
Catherine Weir

FINE ART MORAY SCHOOL OF ART

Libby Amphlett
Colin Bury

ARCHITECTURE EDINBURGH COLLEGE OF ART

Will Guthrie

ARCHITECTURE MACKINTOSH SHOOL OF ARCHITECTURE, GLASGOW SHOOL OF ART

No submissions for 2011

ARCHITECTURE SCOTT SUTHERLAND SCHOOL OF ARCHITECTURE & BUILT ENVIRONMENT, ROBERT GORDON UNIVERSITY

Rick Burney
Seán Gaule

ARCHITECTURE UNIVERSITY OF DUNDEE

Alan Keane

ARCHITECTURE UNIVERSITY OF EDINBURGH

Paul Pattinson

ARCHITECTURE UNIVERSITY OF STRATHCLYDE

Craig Johnstone

DUNCAN OF JORDANSTONE COLLEGE OF ART & DESIGN

UNIVERSITY OF DUNDEE

FOREWORD BY MOIRA PAYNE

ARTISTS

Joss Allen
Kimberly Bartsch
Sinéad Bracken
Fiona Gordon
Charlene Noble
Lyndsey Redford
Vicki Ross
Mary Somerville
Kimberley Stewart
Lisa Ure
Jan Williamson
Colin Wilson

DUNCAN OF JORDANSTONE COLLEGE OF ART & DESIGN

MOIRA PAYNE, PROGRAMME LEADER, ART AND MEDIA

"My work aims to show a different side to things that seem ordinary." Writes Kimberly Bartsch from the selected Djcad graduates this year. Entropy underlined by the extraordinary in the ordinary within the frameworks and structures of the well-oiled wheel. These are beautiful prints.

At Djcad creative people flourish. No times of austerity here. Of course 'money's too tight to mention', students work all hours and get by, and staff observe the anxiety and turmoil of government plans for the Scottish academic agenda.

Meanwhile Sinéad Bracken freely considers the loss of autonomy on a train, the rule of order and ritual: stay within the lines, stay on the path, but the body is heavily contained. The drama of a red light on a wall, Fiona Gordon is defiant with her drawing….. bloody black ink.

The Aythya Marila, The Myopsittacus Monachus, Victoria Ross treasures the language and the birds, slyly (or cleverly) dealt with on polystyrene and bubble wrap. The Isaria Sinclairii hang in there on paper clips, the foxglove, the periwinkle, the crocus and Berberis, this is mainstream medicine and Jan Williamson brings a career with the National Health service and this knowledge to the celebration of the plants that heal.

The serious business of Art Practice, The Still Life, Art History; black boxed, dead flowers are described with a forensic beauty in Charlene Noble's scanograph prints.

Dundee staff lead on research in the arts in Scotland and under this confident and burgeoning umbrella, young and fledgling (not all are young) artists thrive.

Confident times for us… former student Susan Phillipz wins the Turner Prize and we are applauded nationally yet again… as heavy weights in arts education.

The RSA New Contemporaries bring a brilliant platform to the year of 2010 and this group of new talents will continue to raise the game.

Sleeves rolled up, they make things, draw things, film things… used to having everything available; technologies and workshops, opportunities for experimentation and the encouraged use of varied methods, approaches and skills. Experience and opportunity are the hallmarks of our programmes, and painting, video, sound, installation and print, are deployed with no hierarchy, no boundaries, no dogma. Dundee students research with intensity, use digital/ audio/ visual languages clearly and are unafraid to take risks.

Both Lisa Ure and Mary Somerville create spaces and worlds, models and sets. Mary makes an animation, and then animates the world as the viewer encounters the set, the narrative being overturned. Lisa multiplies complexity with VHS playback x 4 on a continuous loop and compounds the stacking with collage photography and print. These are material gestures with processes and technologies, not the usual paint.

Kimberly Stewart painstakingly cuts handmade stencils, building careful layers of household dust that trap gentle quiet memories of the past. Joss Allen is loud, clear, drawings of sound; sculptures translate and transcribe. This is a catalytic practice that embodies a scientific understanding of pure potential.

Colin Wilson and Lyndsey Redford both paint, Colin paints the moving image still, and holds it right there, and Lyndsey's work flows and plays and scribbles and colours, and the image gets lost in the paint.

Whilst describing the work of this year's selected artists I have glanced across the surface of their component parts using easy notes and illustration, however there is more, there is so much more, each artist in this year's show has offered a vision of the world: be it urban political structures, nature and it's species and the consequences of unthinkable loss, philosophical propositions of translation and material metaphor and things. Each artist has developed a curiosity, a passion and is engaged with contemporary critique. Each will spring forward from this opportunity….many thanks to the Royal Scottish Academy.

JOSS ALLEN

GRADUATED: DUNCAN OF JORDANSTONE COLLEGE OF ART & DESIGN

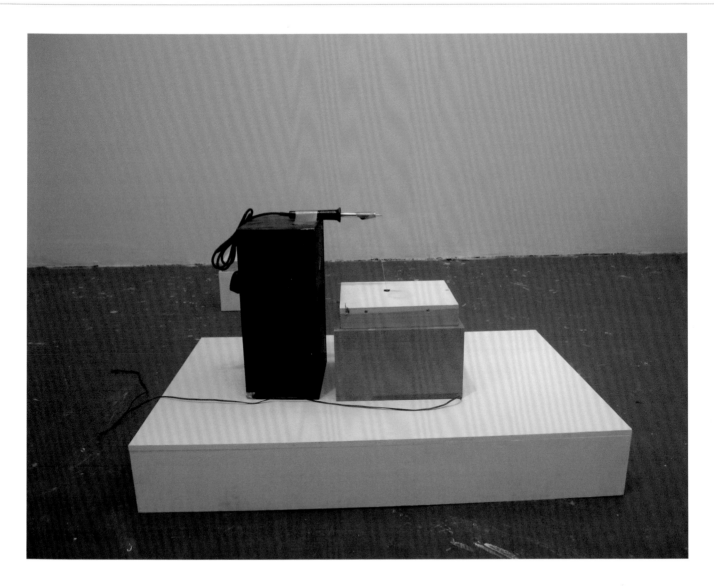

Drawing Machine/ Noise Translator [2009] MDF, wood, found object, soldering iron, paper, speaker driver, cable wire.

Images from left: **Untitled 1** [2010] Screenprint on wood, 120cm x 90cm

Untitled 2 [2010] Screenprint, 30.48cm x 22.86cm

SINÉAD BRACKEN

GRADUATED: DUNCAN OF JORDANSTONE COLLEGE OF ART & DESIGN

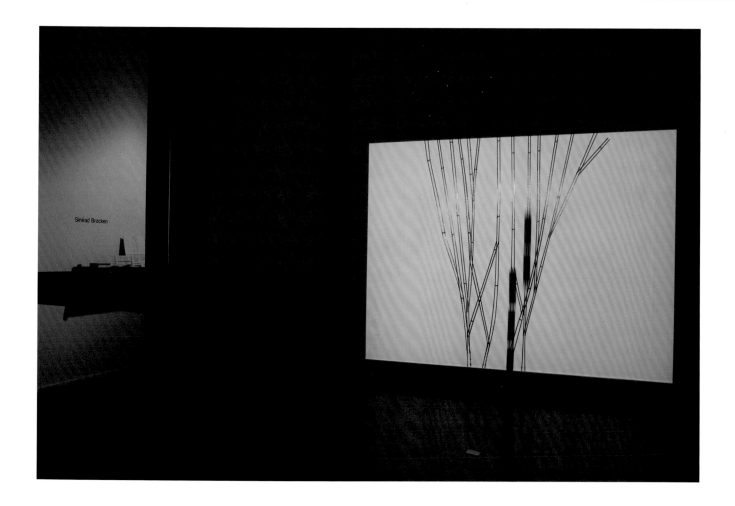

Waverley Station [2010] Animation projected onto wooden structure. Photograph by Matthew Cameron

Images from left: **Shares** [2010] Ink drawing. A1. **Security** [2010] Ink drawing. A1

CHARLENE NOBLE

GRADUATED: DUNCAN OF JORDANSTONE COLLEGE OF ART & DESIGN

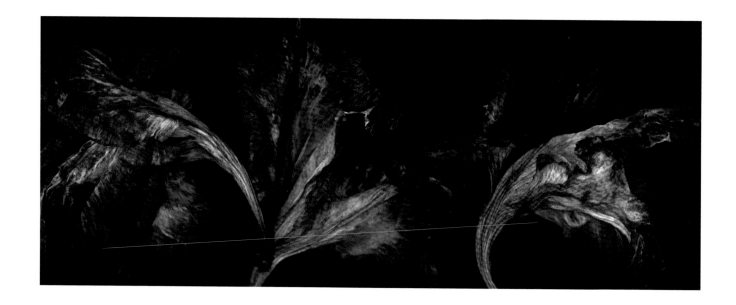

Sentimental [2010] Scanograph, 530 x 960mm

LYNDSEY REDFORD

GRADUATED: DUNCAN OF JORDANSTONE COLLEGE OF ART & DESIGN

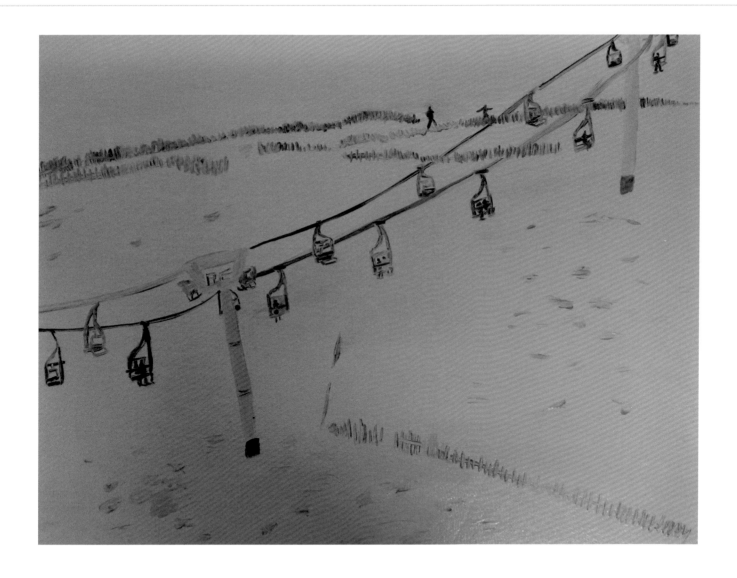

Chair lift [2011] Oil on canvas board. 50cm x 35.5cm

VICKI ROSS

GRADUATED: DUNCAN OF JORDANSTONE COLLEGE OF ART & DESIGN

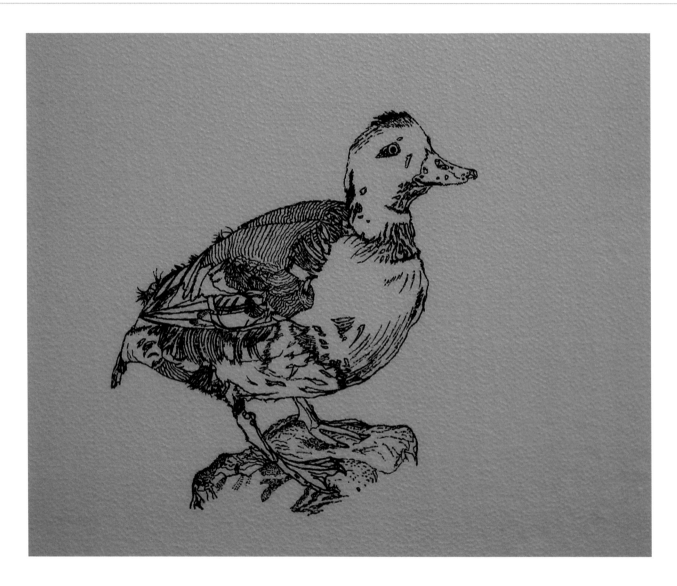

Scaup (Aythya marila) [2009] Black pen on polystyrene, 63.9cm x 59.9cm

MARY SOMERVILLE

GRADUATED: DUNCAN OF JORDANSTONE COLLEGE OF ART & DESIGN

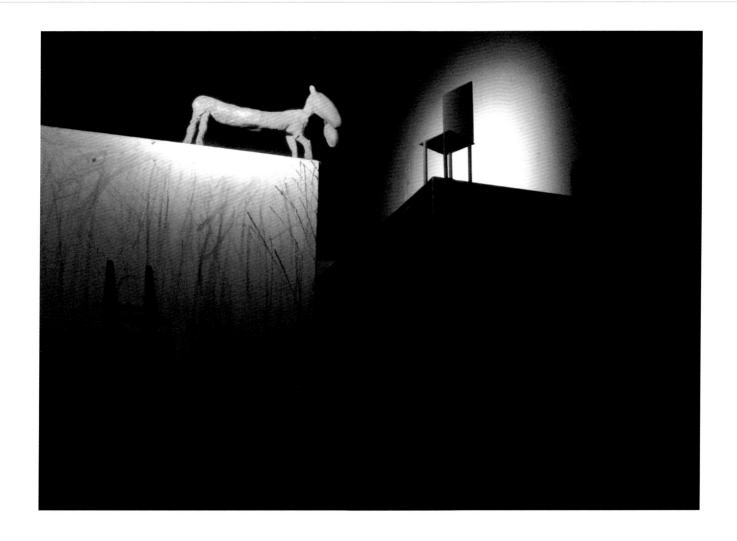

Canyon from Afar [2010] Animation still from 'Continuous Journey One'

KIMBERLEY STEWART

GRADUATED: DUNCAN OF JORDANSTONE COLLEGE OF ART & DESIGN

2881 [2010] Household dust on canvas, 60 x 60cm

LISA URE

GRADUATED: DUNCAN OF JORDANSTONE COLLEGE OF ART & DESIGN

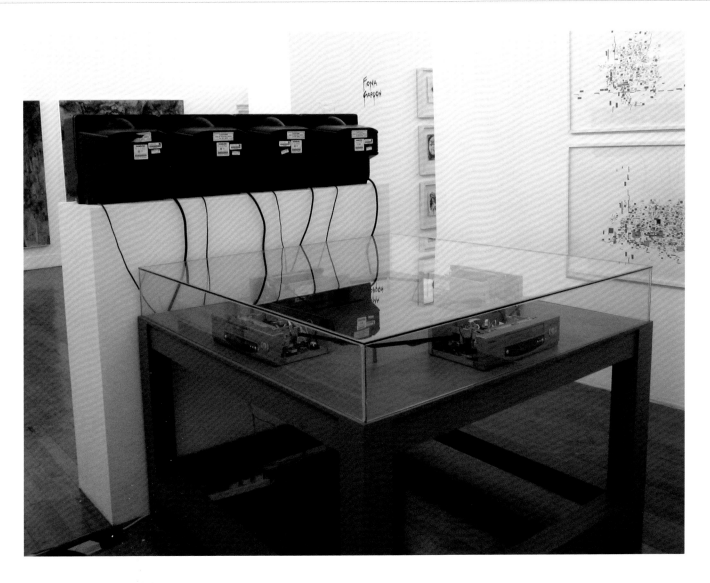

Multiple VHS Playback [2010] Installation View

JAN WILLIAMSON

GRADUATED: DUNCAN OF JORDANSTONE COLLEGE OF ART & DESIGN

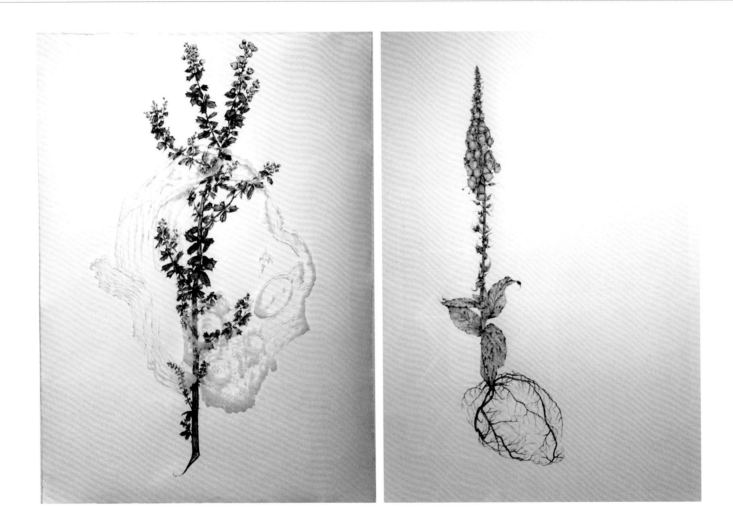

Berberis (Berberine) [2010] Screenprint and watercolour on paper, Screen print on Perspex. 88cm x 124cm

Rhythm Restored (Digitalis purpurea) [2010] Screenprint and watercolour. 88cm x 124cm. Photographed by B. Williamson

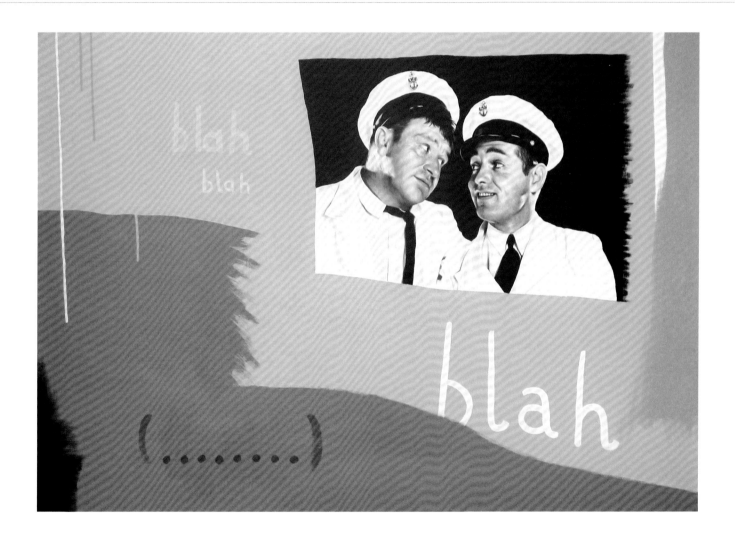

Interjection [2010] Acrylic. 107cm x 76cm

EDINBURGH COLLEGE OF ART

FOREWORD BY STUART BENNETT

ARTISTS

Anne Benson

Jessie Buchanan

Laura Byrne

Joseph Calleja

Arwen Duncan

Shaun Fagan

Alex Gibbs

Geri Loup Nolan

Calum McClure

Francesca Miller

Ruth A Nicol

Jamie Robinson

Gordon Simpson

Kim Wilson

EDINBURGH COLLEGE OF ART

STUART BENNETT, HEAD OF THE SCHOOL OF ART, EDINBURGH COLLEGE OF ART

Today I spent some time trying to work out how oil from a sculpture in a ground floor studio was leaking into a basement studio. Not directly below but, curiously, two studios along. Meanwhile a pigeon was disrupting the crit that was happening on the first floor. It was attracted by the work the students were discussing. The work was made of birdseed.

I've had a tutorial with a talented student who attempted to convince me that a badly modelled dried clay dolphin was the best thing he had made. He seemed so convinced that I left the tutorial concerned about him, anxious that something was wrong. In a crit the a few days later he exhibited a video of himself slumped in a chair next to the 'dolphin' while a professional hypnotist repeated in dulcet tones, "the clay dolphin is the best work I have ever made, the dolphin surpasses all of my other work, the clay dolphin is the best.....".

Concerns about the fabric of the building, the consequences of materials used to make work and the health and wellbeing of the students are ever-present. But this is outstripped by the surprise, wonder, humour, beauty and inventiveness of the stuff that happens in the School of Art.

The making of art stems from a curiosity about the world and to engage in the activity of making art we need to be involved in an exchange with each other about our methods of inquiry. We also need to engage with those outside the art world, also inquisitive about how we live, what we do and our surroundings. Art is about social encounter, making personal choices, establishing a critical attitude. We experiment, make things and need time and space to work out if the things works or what value they might have.

Art is a kind of job that no one asks you to do but the graduates selected for RSA New Contemporaries have been asked to do something.

They have the opportunity to reflect and consider what they should exhibit beyond the support structure of the educational institution. The results will be presented in a different kind of institution, one that reinforces innovation and interrogative tradition through exhibition.

Unfolding artists will exercise individuality and experimentation to challenge perceptions and ensure a vibrant, edgy and evolving demonstration of talent. The permissive atmosphere of art college encourages unorthodox approaches and lateral thinking. The embodiment of that experience in visual and physical form creates new approaches and acts as a friction to conventional thinking. RSA New Contemporaries is an opportunity to challenge a new audience and the artists will have many more. The work will evoke intrigue, attract and rebut, mesmerise and confound, and this vitality will feed us with much needed new thoughts about the world.

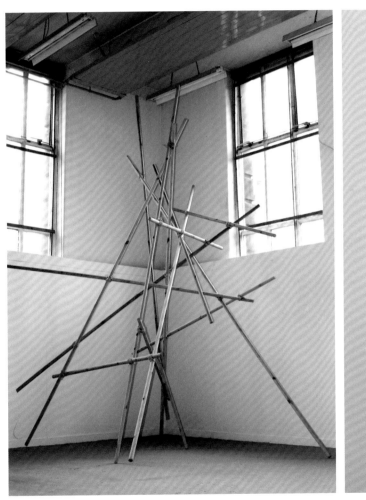
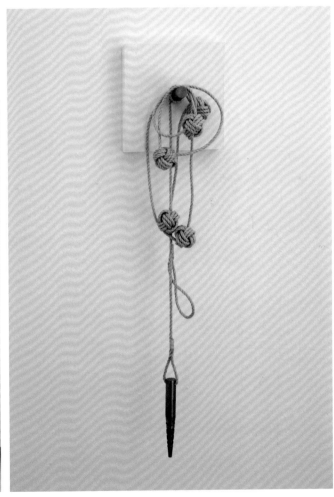

Metang [2010] 15 Redwood pine poles lashed together with 6mm sisal rope, approx. 5.5m x 5.5m

5 Fathoms deep [2010] Sisal rope, mild steel rod

JESSIE BUCHANAN

GRADUATED: EDINBURGH COLLEGE OF ART

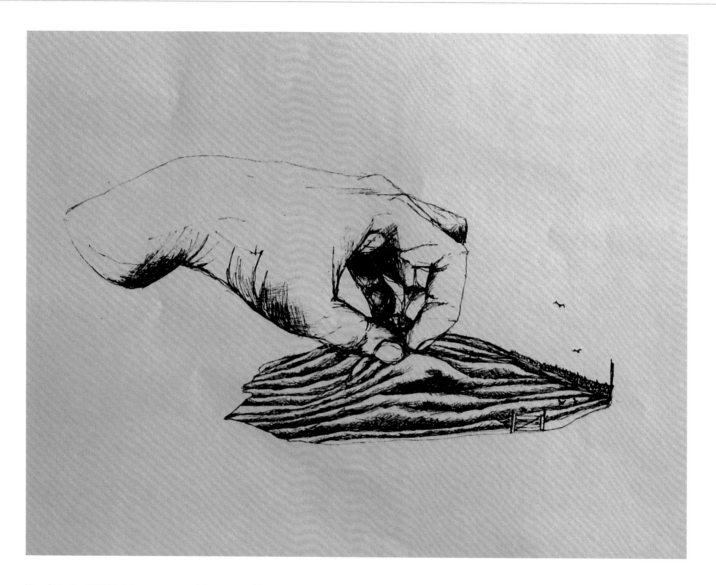

Hand study [2009] Ink pen on cartridge paper. 21cm x 29.7cm

LAURA BYRNE

GRADUATED: EDINBURGH COLLEGE OF ART

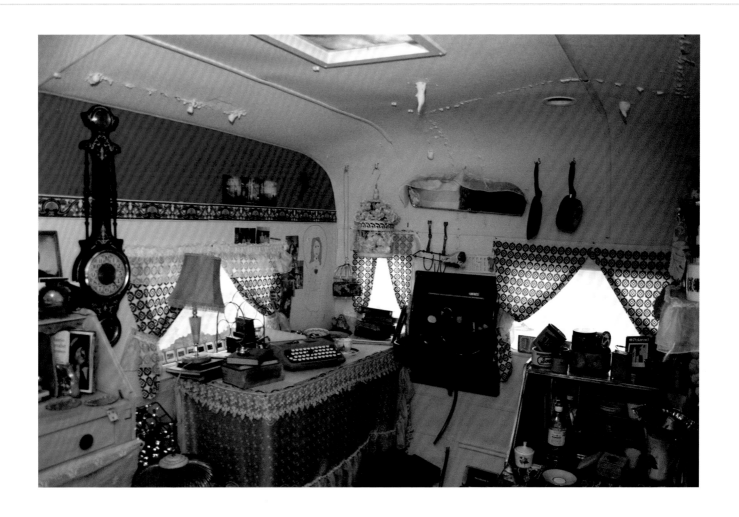

Tyto Alba on the road [2010] Interior of the installation

JOSEPH CALLEJA

GRADUATED: EDINBURGH COLLEGE OF ART

 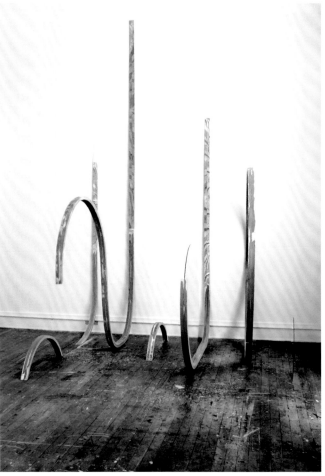

Images from left: **Beneath** [2009] pencil on card. 140 x 100 cm
Tixref [2010] Installation, plywood and glass. c. 460 cm x 300 cm x 250 cm

ARWEN DUNCAN
GRADUATED: EDINBURGH COLLEGE OF ART

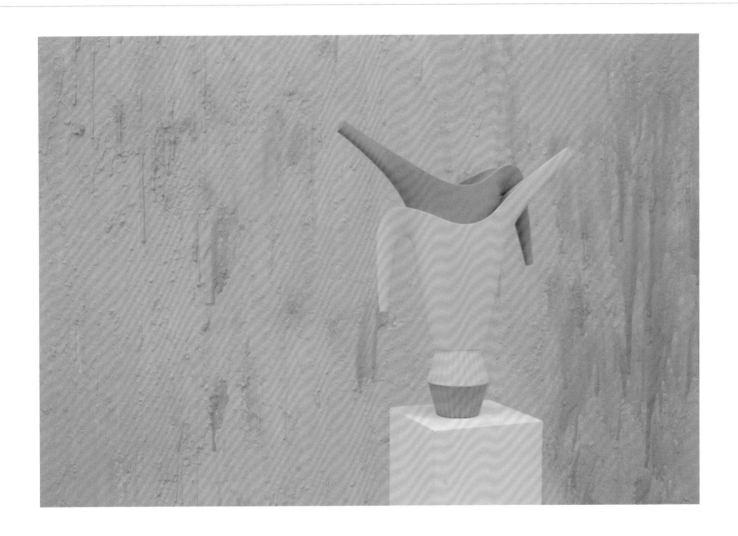

Larder [2010] Plastic Jugs, wooden plinth. 30cm x 40cm x 20cm (Backdrop of Custard Wall; Instant Custard)

SHAUN FAGAN

GRADUATED: EDINBURGH COLLEGE OF ART

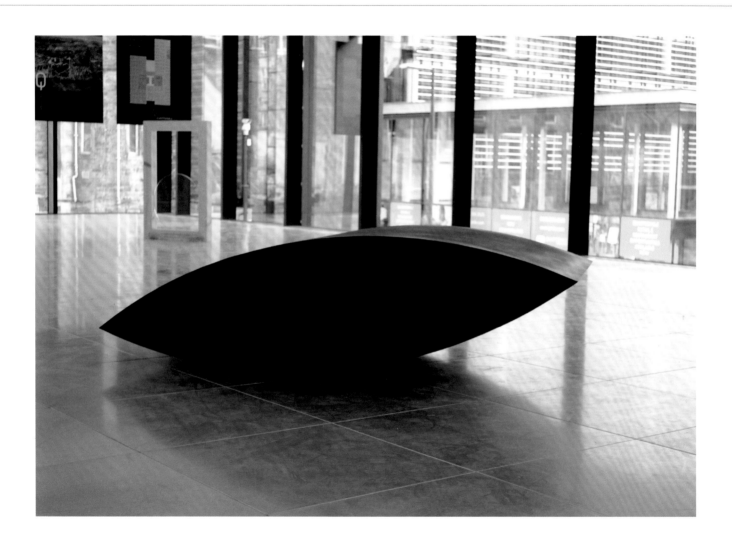

Q1 [2010] Wood, Paint, Weight Shifting Mechanism. 170cm x 45cm x 80cm

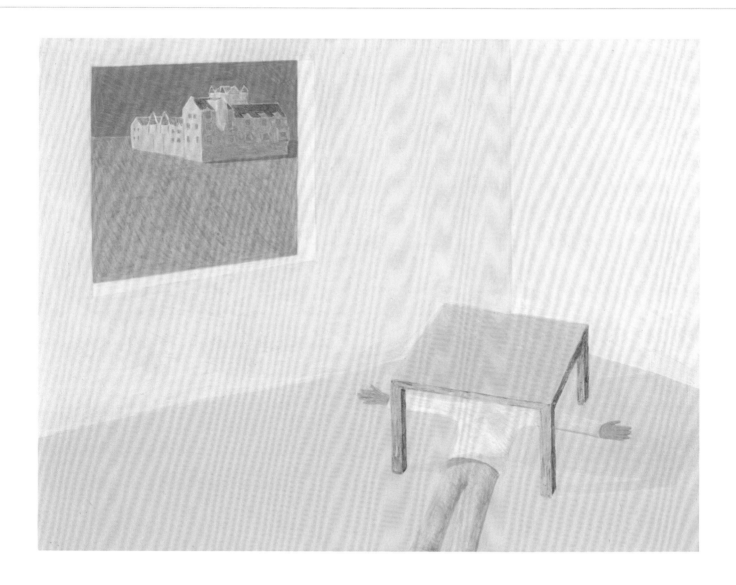

Man under a table, with castle [2010] Acrylic and varnish on board. 15cm x 20cm. Collection of Lady Cawdor

GERI LOUP NOLAN

GRADUATED: EDINBURGH COLLEGE OF ART

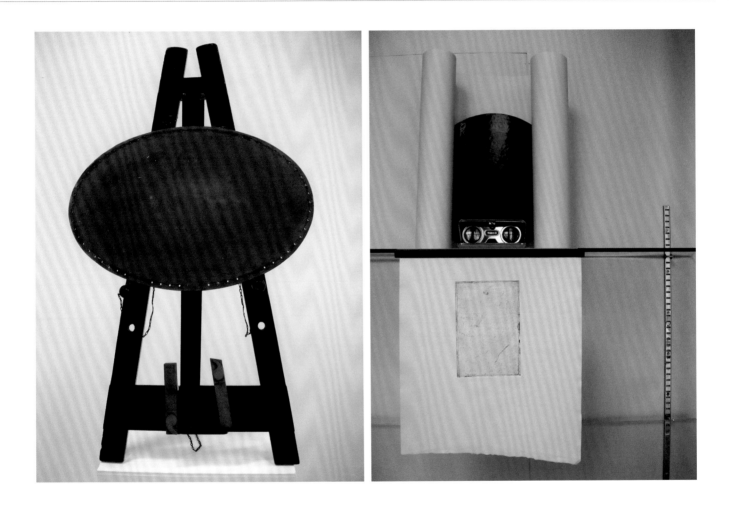

Images from left: **Love After Love** [2010] Mixed Media. 80cm x 50cm.
The Eye I Am [2010] Mixed Media. 30cm x 60cm

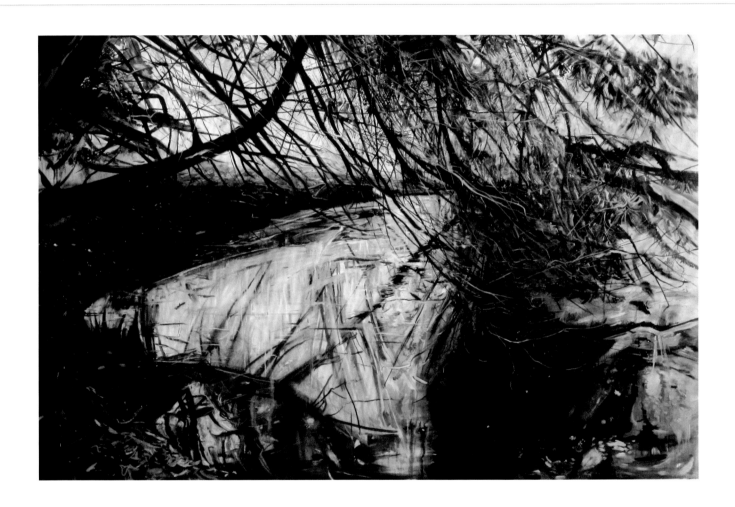

Undergrowth [2010] Oil on board. 124cm x 185cm

FRANCESCA MILLER
GRADUATED: EDINBURGH COLLEGE OF ART

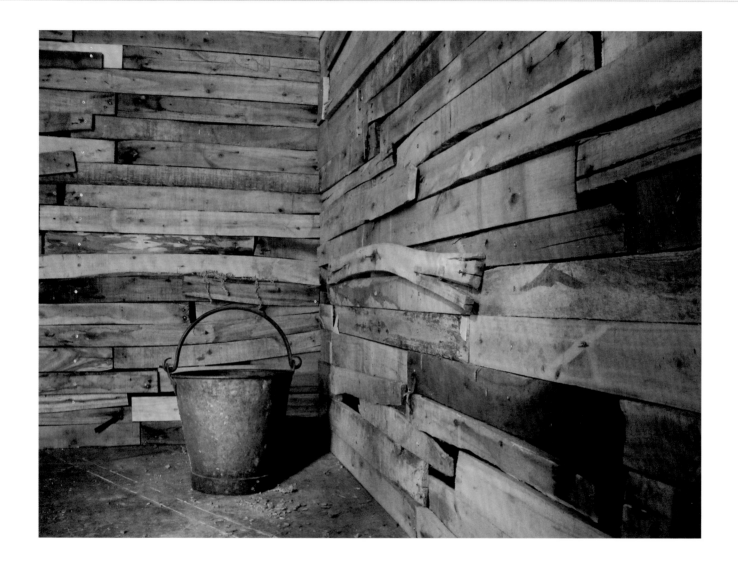

Achnashellach [2010] Mixed media. 300cmx 300cm x 244cm

RUTH A NICOL

GRADUATED: EDINBURGH COLLEGE OF ART

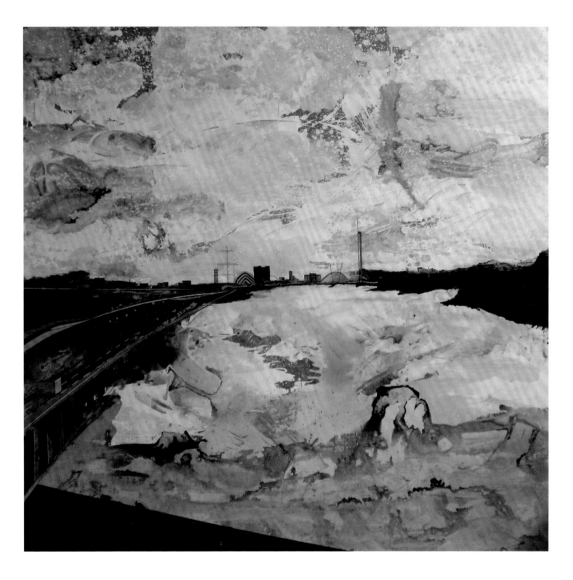

Glasgow From The Riverside Museum [2010] Acrylic On Canvas. 250 x 250 cm

JAMIE ROBINSON

GRADUATED: EDINBURGH COLLEGE OF ART

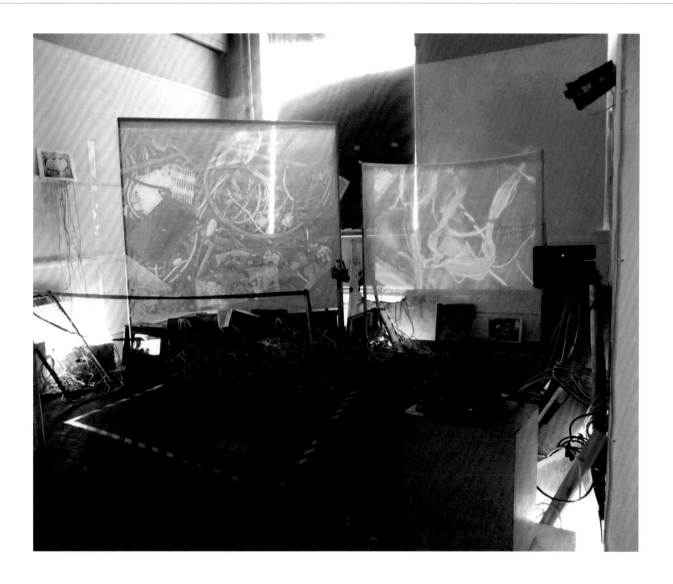

Framing Control [2010] Mixed medium installation with projection

GORDON SIMPSON

GRADUATED: EDINBURGH COLLEGE OF ART

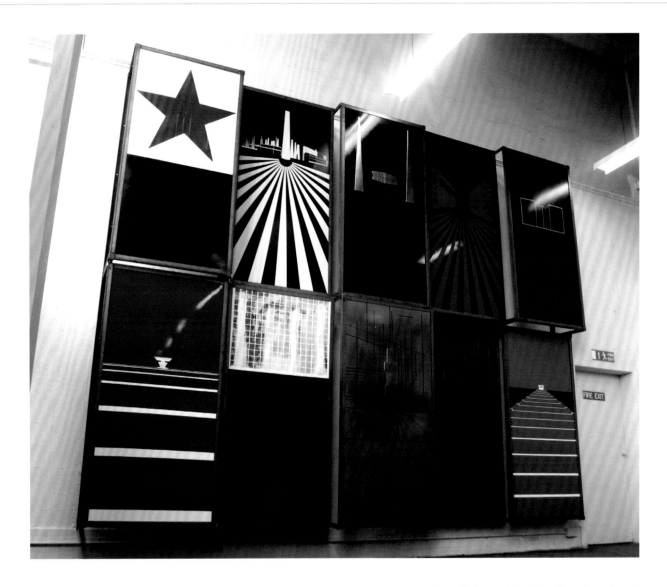

Installation [2010] Mixed media on board

KIM WILSON

GRADUATED: EDINBURGH COLLEGE OF ART

Through which stillness moves [2011] C-type print. 30.1cm x 50.8cm

GLASGOW SCHOOL OF ART

FOREWORD BY PAUL COSGROVE & STUART MACKENZIE

ARTISTS

Martin Bech-Ravn

Naomi Bell

Ben Crawshaw

Diane Dawson

Alyssa Evans

Hazel Gore

Hannah Hewins

Lauren Iredale

Gabrielle Lockwood Estrin

Richard Martin

Paul McDonald

Andrew Nice

Shaun O'Donnell

Timothy Pulleyn

Alex Thornton

Lyndsey Wardrop

Mary Wintour

GLASGOW SCHOOL OF ART

PAUL COSGROVE, ACTING HEAD, SCULPTURE AND ENVIRONMENTAL ART
STUART MACKENZIE, SENIOR LECTURER, PAINTING AND PRINTMAKING

In the predictably chaotic flurry of activity that accompanied the preparations for the GSA Degree Show in the summer of 2009, I doubt if the graduating students gave much thought to the significance of the year in which the event took place. And yet 2009 was a major milestone in the history of the School. By December of that year, the celebrated Mackintosh Building, the building in which their work was displayed and which is revered throughout the world as Charles Rennie Mackintosh's architectural 'masterwork', would be exactly 100 years old.

Since 1826, The Royal Scottish Academy (RSA) has resided in William Henry Playfair's iconic building on the mound in Scotland's capital Edinburgh. From its beginnings and to this present day it has supported upcoming and established artists, enabling them to represent themselves and their work not only to their immediate peers, but to a broad, informed and increasingly international art audience. The RSA's New Contemporaries provides an important and still quite unique arena for recent graduates from across all of Scotland's Art Schools to participate in a professionally curated exhibition that importantly locates an individual's work within a wider field of peers. For many recent graduates this may be a first opportunity to position and review their developing practice in relation to contemporaries on a national level, as they each embark on their individual journeys. This potential of peer review is essential to making art, offering other levels of critical evaluation and reflection. Discussing Matisse and Picasso, Norman Mahler makes historical reference to the special nature of this kind of review, and how they would "illuminate [...] infuriate [...] stimulate" and "galvanize the ambition of the other" with Picasso concluding that "nobody ever looked at Matisse's work as thoroughly as I did". (Norman Mahler's portrait of Picasso as a young man, date and page number)

The importance of the RSA's New Contemporaries is that it supports and highlights the networks that exist and also creates possibilities of new connections and relations. Indeed what binds all of these new contemporaries is their emergence from an Art School Studio based education - a space that is increasingly under threat of erosion - which, gives space and time to develop individual voice through practical and conceptual skills that can and do move between more traditional processes and histories alongside a more expansive field. This is clearly evident in the work of the exhibiting Graduates from Glasgow School of Art.

Art Schools and the studio-based education they support are important places of innovation and at a time where increased efficiency gains are affecting many areas of education and culture, they need and deserve support and investment more than ever. The artists in this show demonstrate the diversity of talent that can emerge from the dedicated time, space and resource such institutions and ways of learning offer to our social, cultural and economic fabric. The artists here merge the local with the international, producing work that showcases Scotland's creative potential and wide reaching influence. The RSA, with its rich history and continued development in new directions reflects these very values, offering a platform of international standing through which to profile a selection of the kinds and levels of talent that can emerge from Scotland's Art Schools.

MARTIN BECH-RAVN

GRADUATED: GLASGOW SCHOOL OF ART

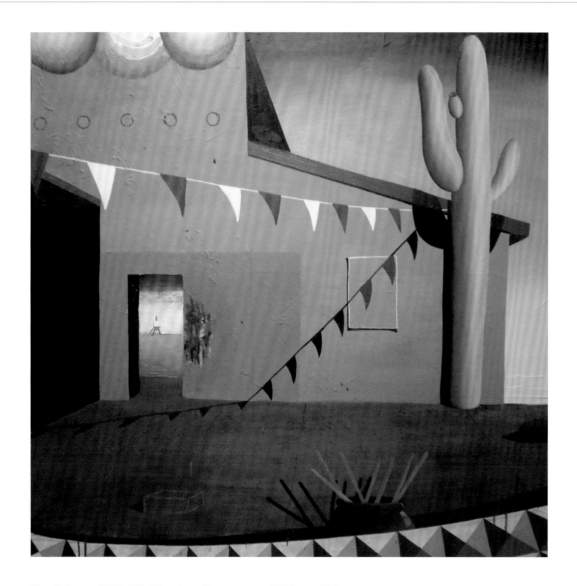

The distance [2010-11] Oil and acrylic on canvas. 125.5cm x 125cm

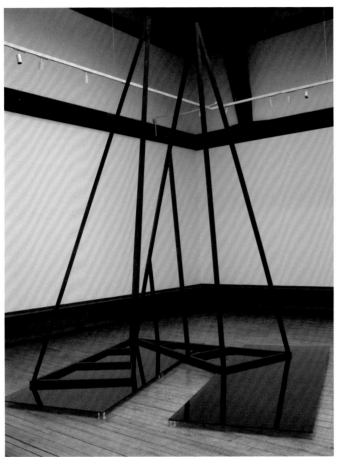 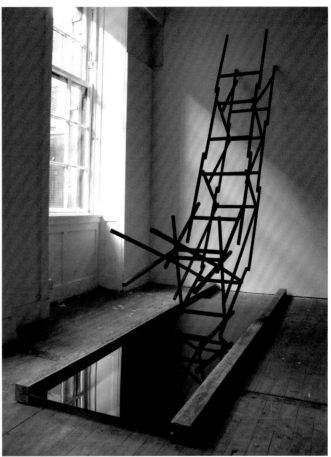

Images from left:

Exsto (to appear, project) [2010] Pine, paint, graphite powder, fabricated toughened tinted glass, perspex. 3.2m x 3m x 4.5m

Augeor (to increase, strengthen, enlarge) [2010] Pine, paint, fabricated toughened tinted glass, concrete. 2.5m x 0.8m x 2.6m

BEN CRAWSHAW

GRADUATED: GLASGOW SCHOOL OF ART

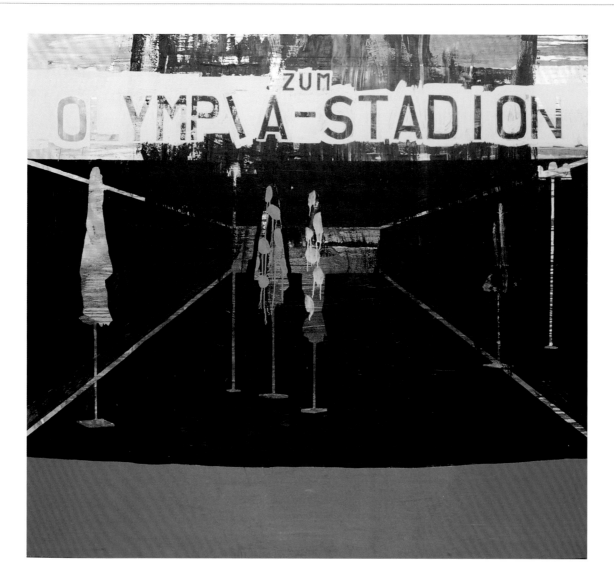

Zum Olympia Stadion [2010] Oil on canvas. 180x170

Glasgow Overspill [2010] Silkscreen. 76 x 64cm. Photo by Alan Dimmick

ALYSSA EVANS

GRADUATED: GLASGOW SCHOOL OF ART

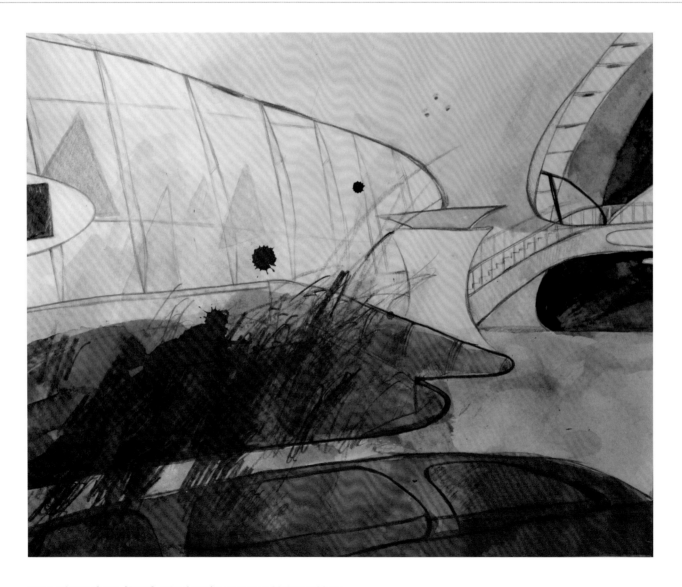

For a minute there [2011] Mixed media on paper. 22.8cm x 28cm

HAZEL GORE

GRADUATED: GLASGOW SCHOOL OF ART

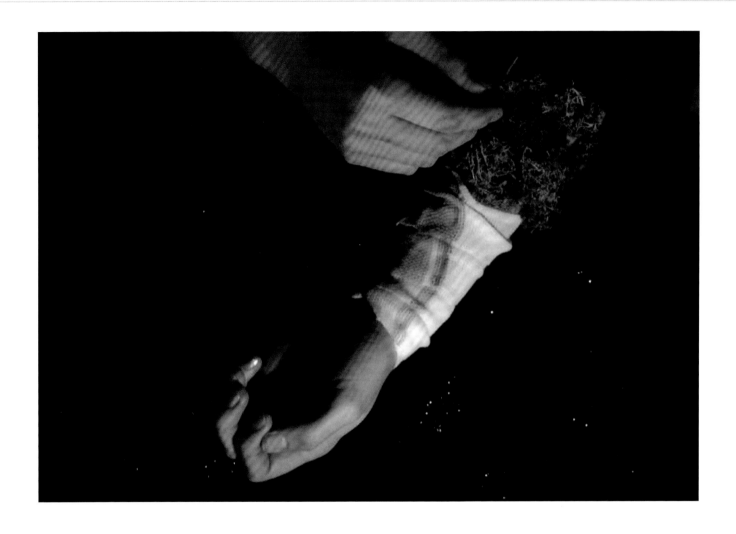

Poison Ivy [2011] Stop motion animation. Photo by Andrew Pattie

HANNAH HEWINS

GRADUATED: GLASGOW SCHOOL OF ART

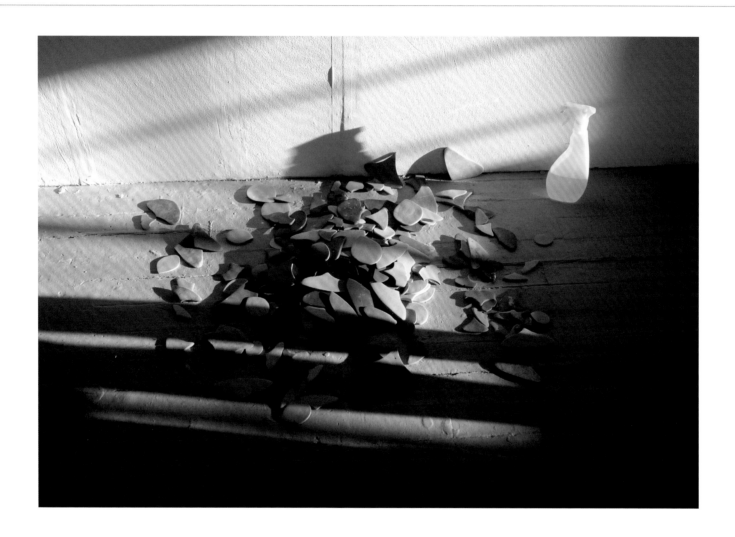

Wing Brace (Installation shot) [2010] Porcelain & plastic water bottle. Approx 80 x 80 x 20cm (size variable)

LAUREN IREDALE
GRADUATED: GLASGOW SCHOOL OF ART

Push [2010] Oil on canvas. 80cm x 90cm

GABRIELLE LOCKWOOD ESTRIN

GRADUATED: GLASGOW SCHOOL OF ART

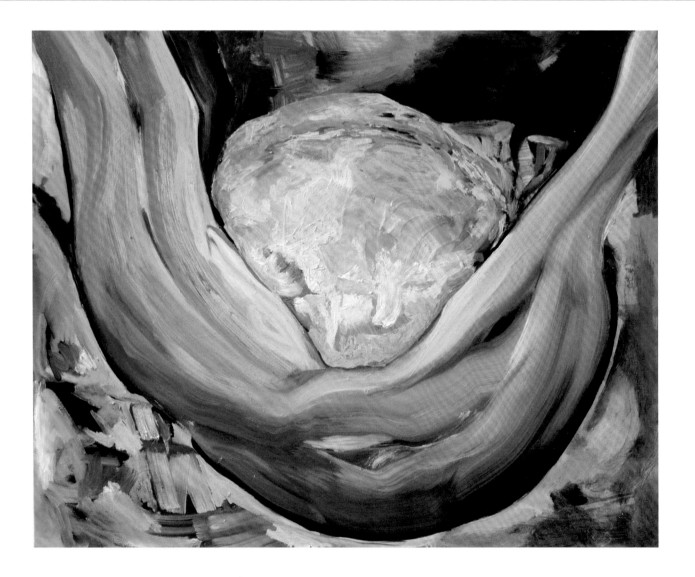

Sling [2010] Oil on Canvas. 65cm x 75cm

RICHARD MARTIN
GRADUATED: GLASGOW SCHOOL OF ART

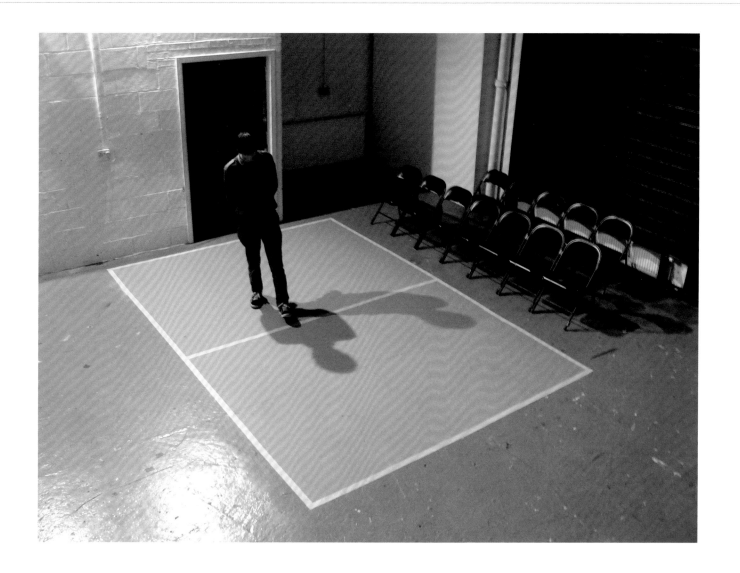

Grey Area [2009] Paint, floor marking tape, metal folding chairs.

PAUL McDONALD

GRADUATED: GLASGOW SCHOOL OF ART

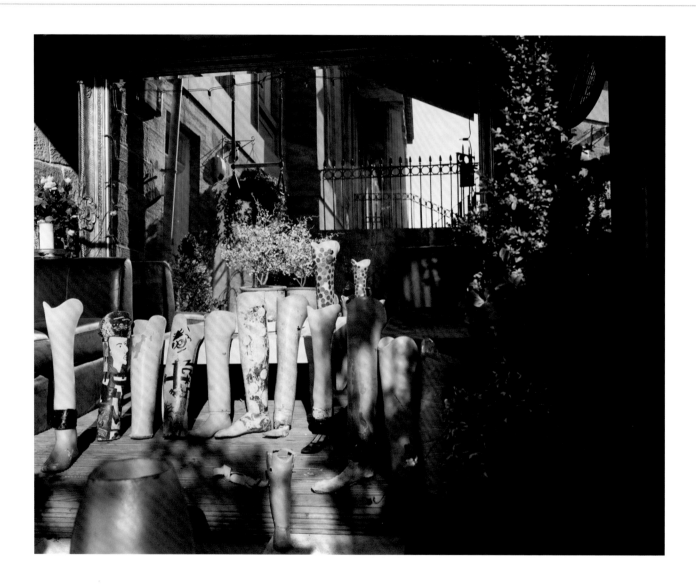

All my legs since birth [2010] C-type print. 81.28 x 101.6 cm

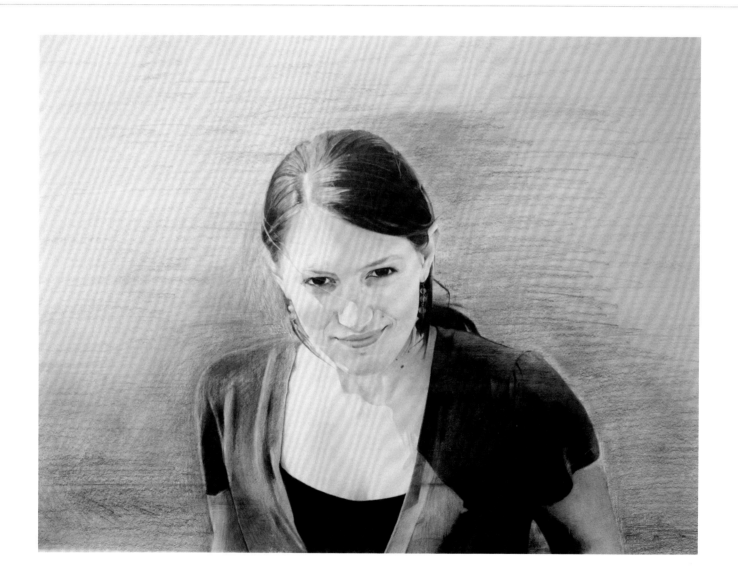

Do you remember the day we went to Cumbrae Island? [2011] Pencil on paper. 66cm x 48.2cm

SHAUN O'DONNELL

GRADUATED: GLASGOW SCHOOL OF ART

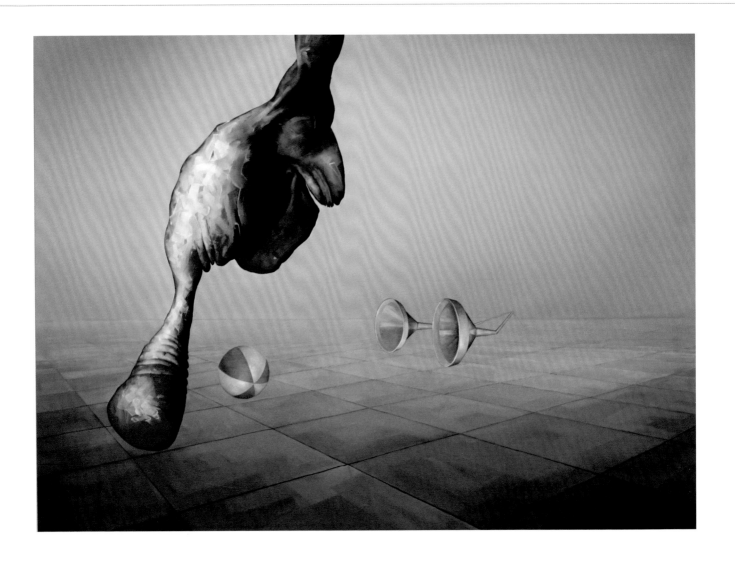

An Illusion of Choice [2010] Oil on Board. 120cm x 90cm

TIMOTHY PULLEYN
GRADUATED: GLASGOW SCHOOL OF ART

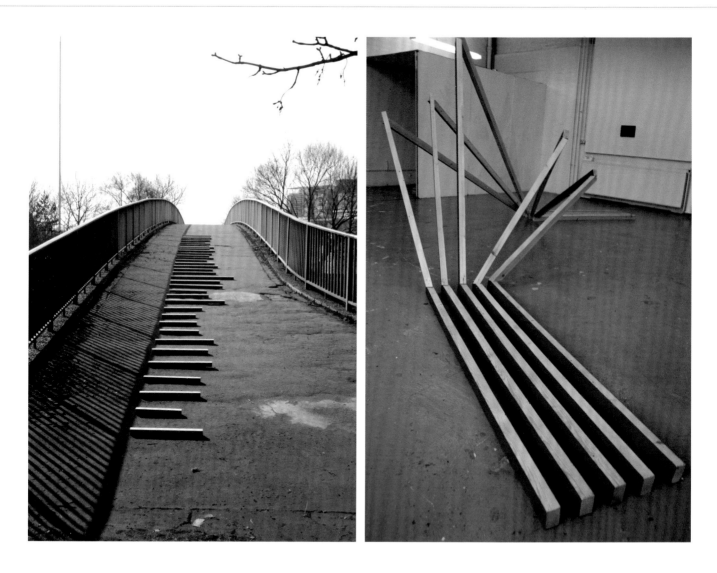

Images from left: **Unit 6 - 43m** [2010] Wood. 43m of 2x2. Photography by Alice Brook
Unit 4 - 43m [2010] 2x2 wood, 6" screws, red paint, adhesive velcro

ALEX THORNTON

GRADUATED: GLASGOW SCHOOL OF ART

Basil and the Flood (detail) [2010] Oil on Paper. Original image 59.4cm x 42cm

Resistance of place (research image) [2011] Concrete, wallpaper and plasterboard

MARY WINTOUR

GRADUATED: GLASGOW SCHOOL OF ART

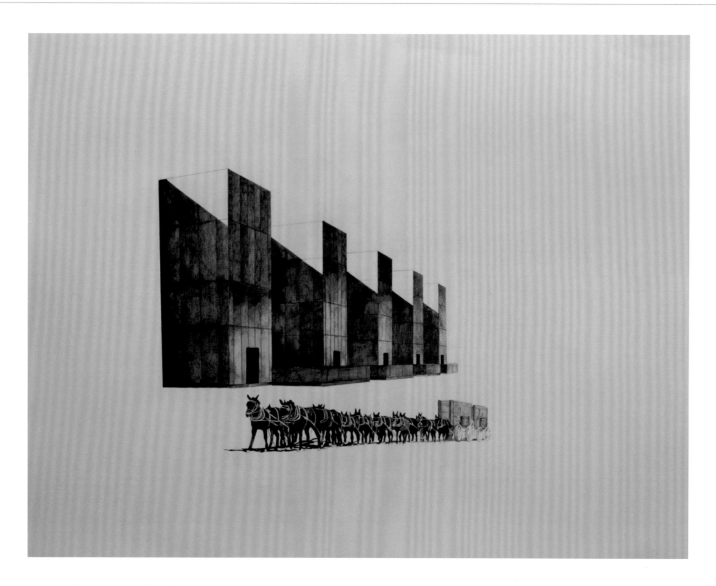

Death Valley to Mojave [2010] Graphite on paper. 48cm x 64cm

GRAY'S SCHOOL OF ART

ROBERT GORDON UNIVERSITY, ABERDEEN

FOREWORD BY ALLAN WATSON

ARTISTS

Laura Campbell

Susan Gauld

Anna Geerdes

Lyndsey Gilmour

Stephen Kavanagh

Alexander Storey Gordon

Stephen Thorpe

Catherine Weir

GRAY'S SCHOOL OF ART

ALLAN WATSON, HEAD OF DEPARTMENT: FINE ART

Any exhibition, especially a group exhibition, may be described as a gathering: a meeting of people, a collection of objects, images, and behaviours. In this specific gathering, whilst your gaze may fix upon the individual work of Gray's graduates Laura, Susan, Anna, Lindsay, Steven, Alex, Stephen and Catherine, I invite you also to consider aspects of co-creation, cooperation and exchange that are a necessary and ongoing condition for the production, dissemination and consumption of art.

The appearance of an artwork in a gallery is the outcome of preferred working methods and application of skills and processes that determine the artist's idiosyncratic language and art form. It has also emerged from the studio's inherent uncertainties, errors and mistakes, and survived to become an assured and confident representation of the artist's practice. If we consider that at this point the artist's work is done, it may also be true to say that it's now up to you, the viewer (or listener, reader, prodder), to activate the artwork.

And so the importance of your role should not be underestimated! You are a vital element in an active process. The philosopher R.G Collingwood writes: 'Art is not contemplation, it is action' and 'the function of the audience is not merely a receptive one but collaborative.' This theory recognizes the dynamic exchange between artist, viewer and artwork. Both creator and audience need the imagination to appreciate the work as art. You are tasked with being a co-creator, imaginatively interpreting the works you encounter in your own way; to extract or project meaning, to smile, frown, nod or despair. Perhaps you'll understand something differently about yourself or ways in which you see or know or sense.

A gathering must occur on a fixed site and whilst the RSA New Contemporaries is located in one specific place, its participants congregate from multiple places. This coming together of 'representatives of place' is another essential form of exchange that is not just vital to the health of an art school environment but of any city, town or wider regional community. As Nuno Sacramento, Director of the Scottish Sculpture Workshop (SSW) writes: "The relationship between the organisation and the place where it is located... mustn't be regarded as a fixed known horizon but as a decisive but fundamentally open element..." Whilst the nascent practice of our graduates will forever be linked to the context of studying at Gray's and living in the North East, each and every one has brought with them something unique from the locale that has shaped them: the Isle of Skye, Kilmarnock, Kirkcaldy, Newport-on-Tay, Brechin, Holland, Glasgow and Aberdeen.

Everywhere is the centre of somewhere and every somewhere depends not only on those who reside there, but on the diversity of people passing through, interacting with one another in a perpetual process of receiving and giving. Learning from one another. But the nature of learning is itself in an evolutionary state. The ever-evolving digital environment unites all of us in the 'information age' where millions of photographs, interviews, reviews or blogs about any artist (or author, theorist, philosopher), from any period or country can be summoned instantly to our desktops. Place simultaneously becomes both local and global. Should such a phenomenon be of concern? Undertaking his 'Scottish Journey' in 1935 the poet Edwin Muir took time to reflect upon the impact that 'movies and the radio' might have on diminishing the unique ability of place to have a 'shaping effect' on those who live and work in a particular place, and came to the conclusion that " ...variety and originality of character are produced by an immediate and specific environment... " It is perhaps reassuring to think that the local will always persist.

Creativity is active everywhere and is not diminished by location, but is instead enriched by location and indeed is perhaps fundamental to that location's 'well-being'. It is vitally important for any region to have a vibrant creative sector and contemporary art has much to contribute to this particular aspect of co-creation. It is difficult to escape the fact that we are in a landscape of public spending cuts and a drastically reduced funding dynamic. Living with such uncertainty puts an inordinate responsibility onto arts organisations and associated educational institutions to form strategic partnerships with industry and business to share and exchange knowledge, to both drive the economy forward and to nurture societal well-being. As Andrew Dixon, Director of Creative Scotland says: "The fact is that culture helps define places and places define the culture of a nation". Whether artist, educator or industrialist we all have a role to play in this creative exchange. So please enjoy the work of our graduates, but don't forget the significance of your part in this gathering.

LAURA CAMPBELL

GRADUATED: GRAY'S SCHOOL OF ART

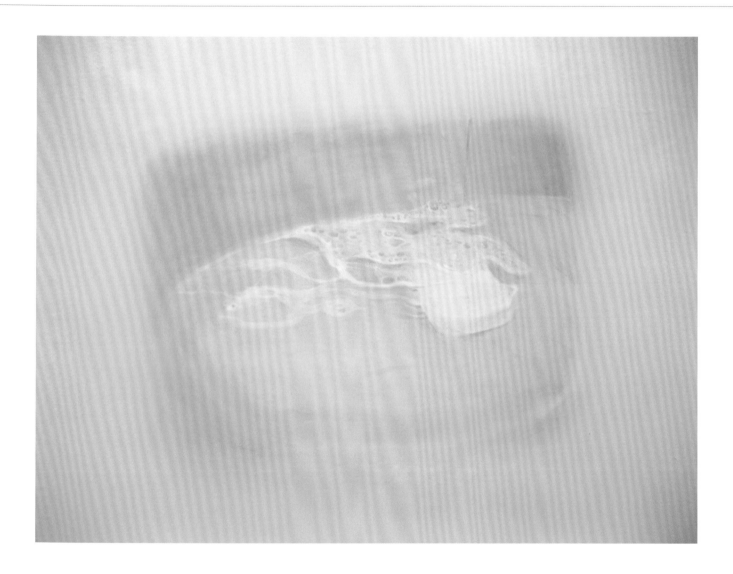

Transitory 2 [2010] Oil on glass. 50cm x 70cm

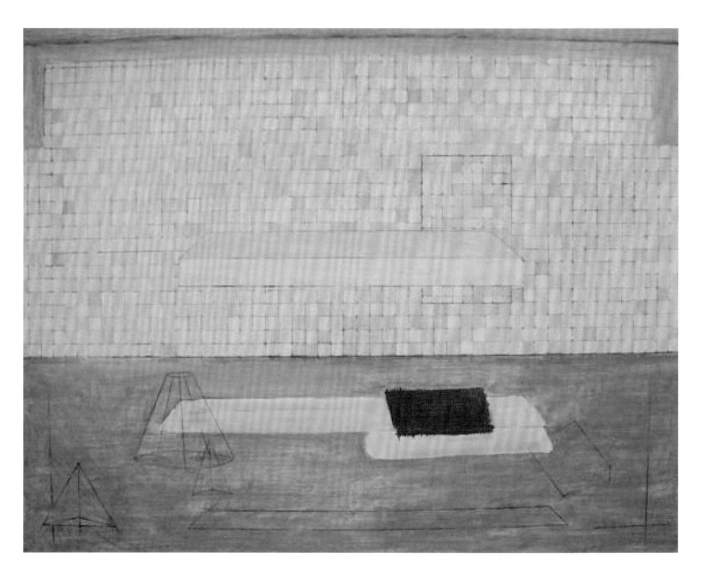

Untitled [2010] Enamel on board. 42cm x 50cm

ANNA GEERDES

GRADUATED: GRAY'S SCHOOL OF ART

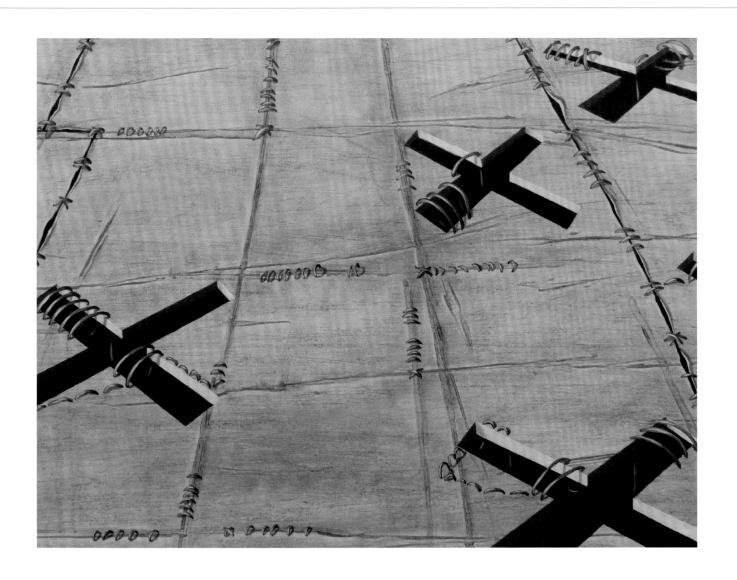

Untitled (Study Utopia Project) [2010] Gesso, shellac, charcoal and oil on paper. 50cm x 63 cm.

LYNDSEY GILMOUR
GRADUATED: GRAY'S SCHOOL OF ART

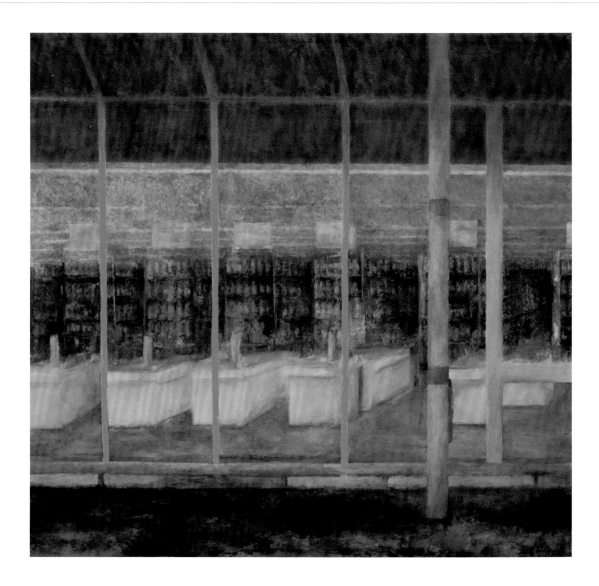

Lit Within [2010] Oil and wax on canvas. 193cm x 208cm. Photography by Stuart Johnstone

STEPHEN KAVANAGH

GRADUATED: GRAY'S SCHOOL OF ART

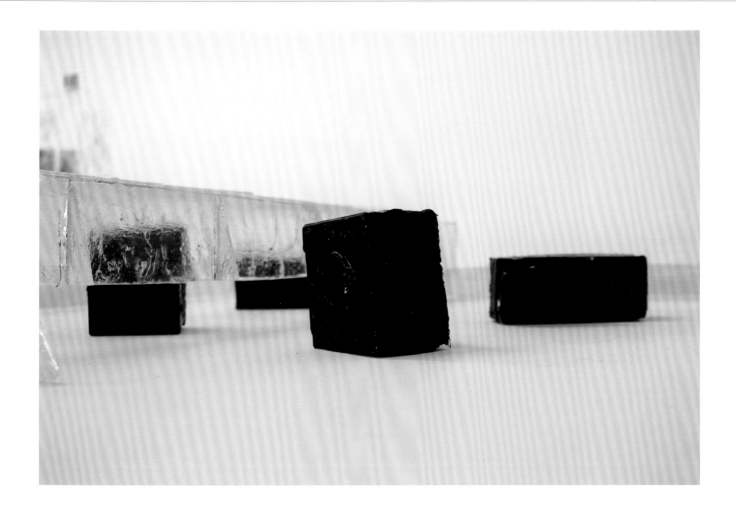

I wish you would look at me like you used to [2010] Resin and silicone. 243.8cm x 122cm.

ALEXANDER STOREY GORDON
GRADUATED: GRAY'S SCHOOL OF ART

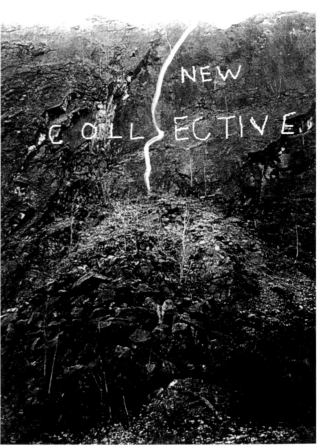

Images from left: **The New Collective Stripes** [2011]. **New Collective** [2010] Photo collage

STEPHEN THORPE

GRADUATED: GRAY'S SCHOOL OF ART

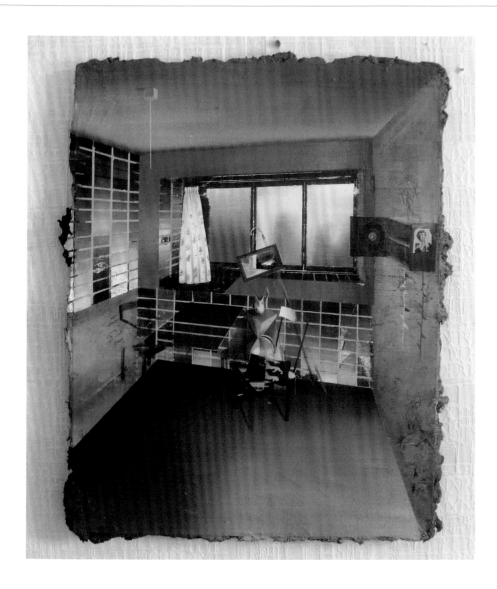

Portraite of a Young Man 1624 [2010] Oil on canvas

70

Candle Clock [2010] Candles, MDF plinth and digitally projected Flash video

MORAY SCHOOL OF ART

MORAY COLLEGE, UNIVERSITY OF HIGHLANDS & ISLANDS, ELGIN

FOREWORD BY GINA WALL

ARTISTS

Libby Amphlett

Colin Bury

MORAY SCHOOL OF ART

GINA WALL, CURRICULUM LEADER

The recent award of university title to UHI has been a hugely significant event for the Highlands & Islands and Moray. It is a strong endorsement of the quality of learning experience that our students have, and the BA (Hons) Fine Art at Moray School of Art is no exception. University title brings obvious benefits, such as a greater national and international profile and research development will be a critical beneficiary in the next few years. The net result of this additional visibility will be increased applications from prospective students from farther afield which brings with it attendant economic benefits to the peripheral communities of the Highlands & Islands and Moray. Although the Art School's reach is already extensive in terms of recruitment from out with our immediate locality, our mission remains to provide high quality, flexible university education in Moray for the people of Moray and the Highlands & Islands. The students who are represented at this year's 'New Contemporaries' are based in the North East of Scotland, continuing to live and to contribute creatively to the region since their graduation in 2010.

Colin Bury's work Construct engages with the natural and the man made, questioning the ease of our relationship with nature. Bury's careful and considered use of materials: recycled slate, functional scaffolding (which can be returned to its designated use) and natural plant materials have a low environmental impact, which is consistent with the artist's general concern.

The artist's use of scaffolding provides a counterpoint to the oak seedlings which make tacit reference to 7,000 Oaks by Joseph Beuys. The scaffold, carefully burnished, sits over the oaks recalling an experimental growing environment which both nurtures and forces growth. In order to ensure that the saplings are in leaf at the time of the exhibition, their growth is carefully planned and regulated, pointing to our sometime complex relationship with the natural world. Whilst Bury's work speaks of environmental custodianship it also references our control and management of nature, giving us a multi-faceted work which is open to several readings.

Construct also hints at the Western conceptualisation of the separation between humans and the natural world, the cultural and natural. Indeed, in terms of etymology of the word culture, this has its origin in the cultivation of the natural. Thus implicit in the term culture we have the sense that human improvement rests upon our own denaturalisation which results in an estrangement from nature. Construct reminds us that by living in culture we are living a myth; a myth in which we have constructed ourselves as set apart from the natural world. The piece posits a past (the seedlings have been raised for the exhibition) and also a future: the trees will continue to grow but only if they are nurtured and cared for. All we can do is imagine what their futures might hold.

Libby Amphlett's work also engages with the environment albeit in a different context. Glascarnoch 2 investigates the effects of technology on the landscape, the overlay of human intervention on the land and the resulting visual impact. The artist has spent time exploring, photographing, drawing and collecting in and around Glascarnoch dam. In addition, through interviews with the descendents of people who lived in the valley she takes cognisance of the human cost of technological progress in terms of the loss of a way of life. Her use of low archaeology and the assembly of an archive facilitates an engagement with the personal, everyday items with which the residents of the flooded valley would have had regular commerce.

The artist has collected shards of pottery and glass collected from the footprints of ruined houses on the floor of the dam during periods of low water. These fractured vessels are reassembled to form hybridised objects which are displayed

on concrete plinths which echo the structure of the dam. Her choice of display resonates with Michel Foucault's notion of the heterotopia, the museum style display of these remade artefacts turns the exhibition space into a place of difference. Indeed, the artefacts are signifiers of difference, their misshapen appearance informed as much by voids and absences as the shards themselves. They are mementoes of a lost way of life which once shattered cannot be properly reclaimed.

Both artists deal with the difficult relationship between nature and culture in divergent visual ways although both share a central concern. Each artist compels us to consider the impact of human activity on the landscape and the environment. In understanding our surroundings, we begin to know where we are.

In our increasingly decentralised world, the UHI and Moray School of Art, offer new educational choices on the periphery of Scotland. The periphery, far from parochial, is a learning network connected by Academic Partners, which provides the opportunity to learn in a geographically dispersed region. The University of the Highlands and Islands, like all Higher Education Institutions, faces extreme challenges in the near future but our graduates are our greatest ambassadors, and it will be through their artistic endeavours that the difference will be made and the UHI mission to contribute to the creative and economic development of the region will be achieved.

LIBBY AMPHLETT

GRADUATED: MORAY SCHOOL OF ART

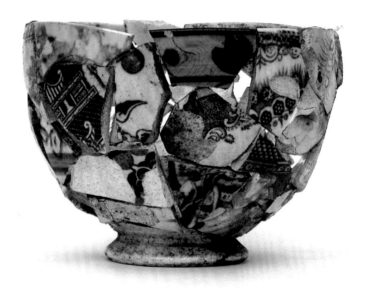

Glascarnoch 2 (detail) [2010] China fragments. Height 8cm

COLIN BURY
GRADUATED: MORAY SCHOOL OF ART

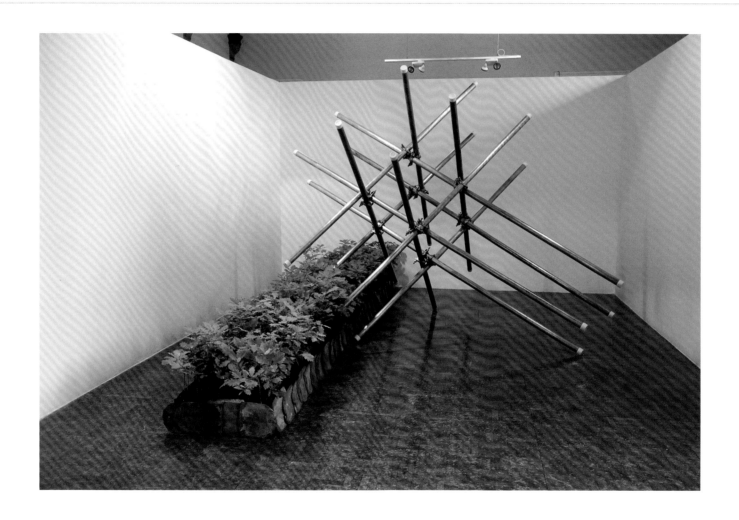

Construct [2010] Scaffolding, living oak seedlings, reclaimed roofing slate. 6m x 6m x 2m

ARCHITECTURE

FOREWORD BY GARETH HOSKINS RSA (ELECT)

EDINBURGH COLLEGE OF ART
Will Guthrie

SCOTT SUTHERLAND SCHOOL OF ARCHITECTURE & BUILT ENVIRONMENT
Rick Burney
Seán Gaule

UNIVERSITY OF DUNDEE
Alan Keane

UNIVERSITY OF EDINBURGH
Paul Pattinson

UNIVERSITY OF STRATHCLYDE
Craig Johnstone

ARCHITECTURE

GARETH HOSKINS RSA (ELECT), ARCHITECTURE CONVENOR

These are challenging times for architecture. The effects of the economic downturn and the subsequent public spending cuts have had a dramatic impact on the scale and output of the profession. And 'design', once at the heart of Labour's 'Cool Britannia', appears not only to not feature within the current UK Government's agenda, but is publicly vilified by ministers, with 'award winning architects' being held up as the root cause of overspends on public projects.

This lack of understanding of the value that well considered architecture and design can bring to the quality of our lives and places is further emphasised in the attitudes towards education within these subject areas, with courses being downgraded and integrated with what are seen as more tangible vocations such as engineering. Coupled with the pressures on funding and the cost of university education, this must be a daunting time for those embarking on courses and entering an uncertain professional world.

A recent lecture visit to one of Scotland's architecture schools brought home the very real challenges currently facing students trying to pursue a life in architecture. After six years of study, only a handful were able to find employment in architecture with the others finding work in areas as varied as telesales and plumbing.

Despite this difficult background, it is hugely encouraging to see the continued vibrancy and wealth of creative talent being nurtured within Scotland's schools of architecture, as evidenced by the projects exhibited in the schools' degree shows and shown within this year's New Contemporaries exhibition. However whilst the typical focus on final years on large scale public projects persists and in instances is taken to almost self indulgent extremes, there is evidence of a change in emphasis with students exploring projects more rooted in an exploration of more everyday issues and situations that effect the cohesion and sustainability of their local places and communities.

This year's selection of projects for New Contemporaries typifies this range of concerns.

Paul Pattinson of Edinburgh University and Alan Keane of Dundee, present proposals for building types that are often typical fare for final year students – the museum and the theatre – both typologies that have traditionally been a fertile playground for architectural expression. Both projects however look beyond the often internalised worlds of these building types to explore how they respond and connect to the wider situation of the city centre sites they occupy. Keane's 'Theatre of the City' introduces a new monumental form into the fabric of Edinburgh's New Town, at once stark and harsh against its highly modelled surroundings and intimate and affecting in terms of the experience of the interstitial spaces and routes that cut through the building and connect it to the city. Pattinson's 'Table Manners: The Medici Bank Museum' creates a complex series of spaces and levels that connect between the Vassario Corridor and the banks of the Arno, to tell the story of Florence's history of banking – a comment perhaps on the controlling influence that such institutions have had historically and continue to have in relation to our societies.

This connection to and understanding of place is echoed in the submissions from Scott Sutherland School of Architecture – both submissions develop projects around the growing awareness of localised production and the development and support of sustainable communities. Sean Gayle's 'Mussel and Oyster Farm' introduces a new working structure at Cramond to take advantage of the improvements in the water quality of the Forth to reinstate a historic industry. Rick Burney's 'Market for the City' creates a new community within Aberdeen around a market place for local produce – a place of everyday activity that reintroduces life and repairs a neglected area of the City.

The final two projects, from Edinburgh College of Art and Strathclyde University are both informed by a narrative treatise

that takes the observer on a journey through which various scales of architectural intervention develop over time. Will Guthrie's 'Gold Library of Cononish' creates an almost mythical place – a repository for knowledge that endures beyond our current digital technologies – whilst Craig Johnstone's 'National Apiological Network' proposes a series of interventions based around the honey bee that might inform and influence our lives from both the experience of the individual to the attitude of society as a whole.

As ever, a range of thought provoking ideas and propositions from a group of creative individuals now embarking on a further journey that will hopefully allow them to develop their thinking within real applications.

In recent years there has been a reversal of the flow of this talent from Scotland, with students who may previously have moved on to London, staying and becoming part of the growth of a group of architectural practices who are becoming increasingly recognised internationally for their thoughtful and creative approach. In a political culture that seems unable to recognise and encourage this home grown talent, the RSA's New Contemporaries show is hugely important in providing a platform not only for the participants but also to celebrate and encourage the creativity within Scotland.

The challenge now for the schools of architecture and their students, is creating a balance that maintains and fosters the spirit of creativity and exploration evident from this year's submissions, whilst having a relevance and robustness that can contribute to developing the debate and ambition for architecture in Scotland.

WILL GUTHRIE

GRADUATED: EDINBURGH COLLEGE OF ART

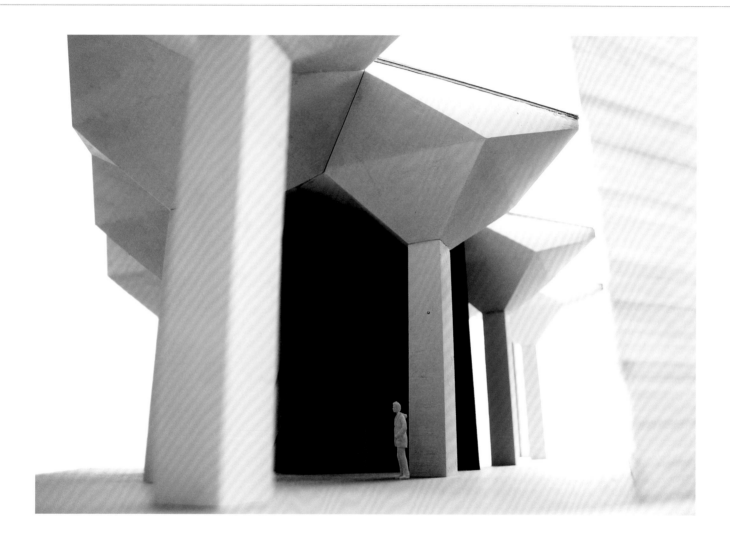

Model of the Cononish Guild [2010] Plaster, ply, card, acrylic. 1:50.

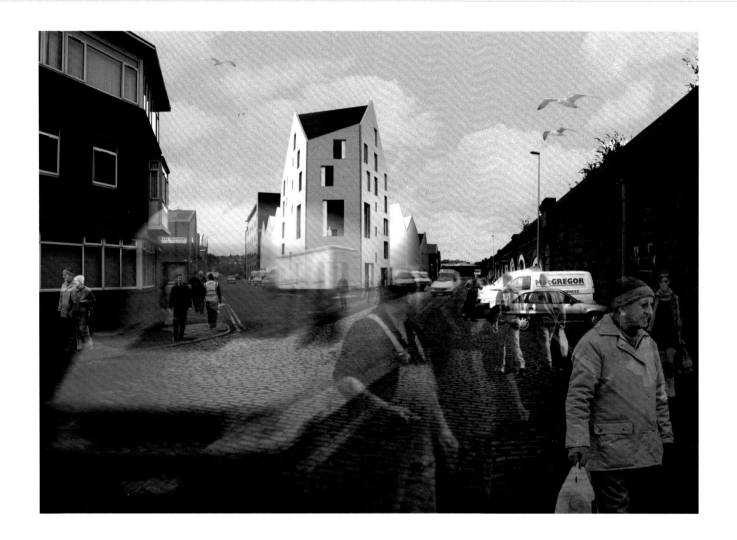

Project Title: **A Market for the City | A City for a Market, Aberdeen** [2010]

SEÁN GAULE

GRADUATED: SCOTT SUTHERLAND SCHOOL OF ARCHITECTURE & BUILT ENVIRONMENT

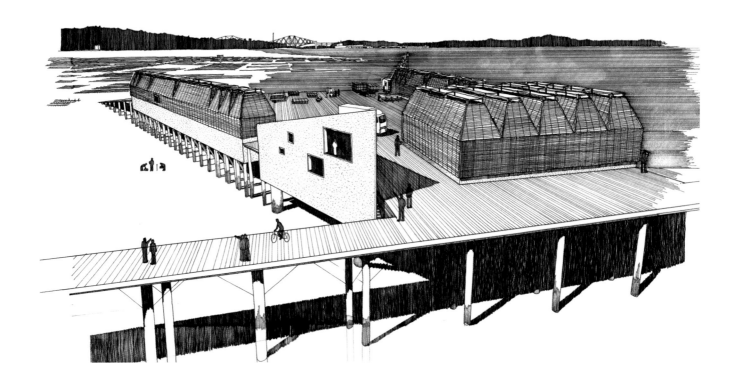

Perspective 1: Oyster farm western perspective [2010] Pigment ink on trace. 84cm x 59cm

ALAN KEANE

GRADUATED: UNIVERSITY OF DUNDEE

View from Princes Street Gardens [2010] Augmented photo. A4

PAUL PATTINSON

GRADUATED: UNIVERISTY OF EDINBURGH

Tavola Rotto Masks Sub-Assembley_Local Scale_Elevation (a) - (a)

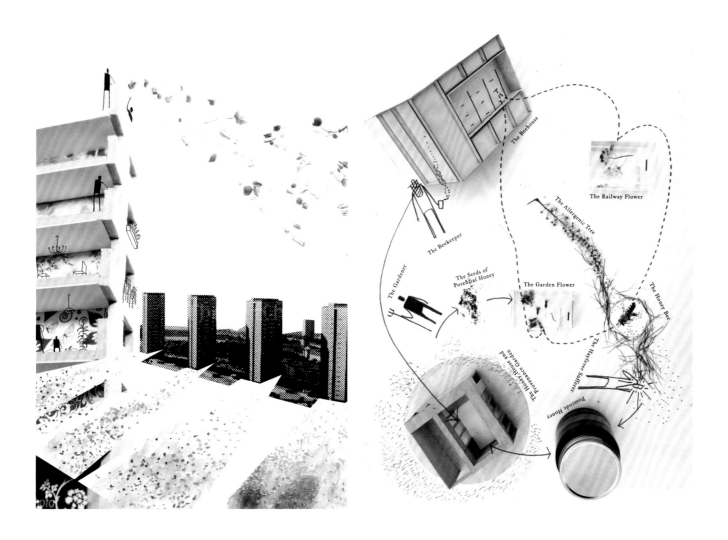

Image from left: **The Honey Bee and The Neighbourhood** [2010]
The Honey Bee and The Flower [2010]

RSA NEW CONTEMPORARIES
LIST OF AWARDS

The Royal Scottish Academy would like to take this opportunity to thank all of the award givers at the RSA New Contemporaries exhibition for the generous prizes and opportunities they offer in support of emerging artists in Scotland. The following awards will be presented at the opening reception.

THE STEVENSTON AWARD FOR PAINTING [£5000]

RSA SIR WILLIAM GILLIES BEQUEST AWARD [£2000]

FRIENDS OF THE ROYAL SCOTTISH ACADEMY AWARD [£500]

RSA PAINTING PRIZE & THE MACLAINE WATTERS MEDAL [£400]

RSA SCULPTURE PRIZE [£400]

RSA ARCHITECTURE PRIZE [£400]

RSA PRINTMAKING PRIZE [£400]

RSA CARNEGIE TRAVELLING SCHOLARSHIP FOR PAINTING [£200]

RSA ADAM BRUCE THOMSON AWARD FOR ANY CATEGORY [£100]

RSA LANDSCAPE AWARD FOR A DRAWING, OIL OR WATERCOLOUR [£100]

RSA CHALMERS BURSARY FOR ANY CATEGORY [£75]

RSA STUART PRIZE FOR ANY CATEGORY [£50]

RSA CHALMERS-JERVISE PRIZE FOR ANY CATEGORY [£30]

RSA NEW CONTEMPORARIES
LIST OF AWARDS

DAVID & JUNE GORDON MEMORIAL TRUST AWARDS
FOR WORKS BY ARTISTS BORN OR STUDYING IN GRAMPIAN REGION

EDINBURGH PRINTMAKERS AWARD
PRINTMAKING COURSE, MEMBERSHIP AND STUDIO SESSIONS

EDINBURGH SCULPTURE WORKSHOP GRADUATE RESEARCH AWARD
ONE MONTH WORKING IN ONE OF THE ESW GARDEN PAVILIONS
PLUS FEE, SUPPORT AND FREE MEMBERSHIP

GLASGOW PRINT STUDIO AWARD
FREE MEMBERSHIP AND SESSIONS FOR ONE YEAR

PEACOCK VISUAL ARTS AWARD FOR MOVING IMAGE
6 MONTHS FREE ACCESS TO PEACOCK'S DIGITAL FACILITY

ROYAL INFIRMARY EDINBURGH PURCHASE PRIZE
SELECTED BY NURSING STAFF OF THE RIE FOR PERMANENT DISPLAY AND ACCESSION INTO
THE NHS LOTHIAN PERMANENT COLLECTION. SUPPORTED BY HOPE SCOTT TRUST

***NEW* SIERRA METRO EXHIBTION AWARD**
OPPORTUNITY FOR EXHIBITION OF NEW WORKS WITH SIERRA METRO. THE SIERRA METRO CURATORIAL
TEAM WILL AWARD AN ARTIST OR ARTISTS WHO HAVE DEMONSTRATED A COMMITMENT TO THEIR
PRACTICE AND AN AMBITIOUS APPROACH WITHIN THEIR PRESENTATION AT
THE RSA NEW CONTEMPORARIES EXHIBITION

THE SKINNY AWARD
EXHIBITION OPPORTUNITY, IN PRINT AND ONLINE EDITORIAL COVERAGE AND ASSOCIATED PUBLICITY
THE SKINNY MAGAZINE GUARANTEES A SELECTED ARTIST A DOUBLE PAGE SPREAD IN THE SKINNY
SHOWCASE ALONGSIDE ARRANGEMENT OF AN EXHIBITION, VENUE HIRE, EDITORIAL COVERAGE IN
PRINT AND ONLINE, ADVERTISING AND PRESS PROMOTION. A LAUNCH EVENT WILL ALSO
BE ORGANISED BY THE SKINNY ON BEHALF OF THE ARTIST.

INDEX OF ARTISTS

If you wish to get in touch with any of the artists from this exhibition, please contact the Royal Scottish Academy:

The Royal Scottish Academy
The Mound, Edinburgh
Telephone: 0131 624 6556
Email: info@royalscottishacademy.org
www.royalscottishacademy.org

ACKNOWLEDGEMENTS

RSA NEW CONTEMPORARIES 2011

The Royal Scottish Academy would like to thank Charlene Noble for use of her image to publicise the exhibition. Thanks also to the Hanging Committee: Alexander Moffat RSA (Convener), Gareth Hoskins RSA (Elect) (Depute Convener), Doug Cocker RSA, Lennox Dunbar RSA, Ronald Forbes RSA, Marion Smith RSA, Adrian Wiszniewski RSA, the Exhibition Staff and Neil Mackintosh and his team for their work in presenting the show. Also thanks to the staff of the Art Colleges and Architecture Schools in Scotland for their invaluable input and support. Thanks to Stuart Mackenzie and Paul Cosgrove, Gina Wall, Allan Watson, Stuart Bennett, Moira Payne and Gareth Hoskins RSA (Elect) for their illuminating essays for the publication. A thank you to; Lara Moloney at The Skinny; Jane Nicol at The Spencerfield Spirit Company; and to Kevin Richardson and 21 Colour for their invaluable assistance in delivering the catalogue.

Also thanks to the external prize-givers: The Stevenston Trust; The Hope Scott Trust; The Royal Infirmary Edinburgh; The Friends of the RSA; The David & June Gordon Memorial Trust; Peacock Visual Arts; Edinburgh Sculpture Workshop; Edinburgh Printmakers; Glasgow Print Studio; Sierra Metro and The Skinny.

We wish to extend a very special thanks to our media partner The Skinny, and to 21 Colour, Glasgow for supporting the print of the publication. Thanks also to The Spencerfield Spirit Company for their support of the RSA New Contemporaries opening reception.

Finally, a thank you to all the participating exhibitors — we wish you well for the future and hope that you will remain in touch with us as your careers continue to progress.

Administration by Colin R Greenslade, Gail Gray, Pauline Costigane, Jane Lawrence, Alisa Lindsay, Susan Junge, Andrew Goring, Julie McCurdy and Emma Pratt. Exhibition Staff: John Biddulph, Dorothy Lawrenson, Abigail Lewis, Emma Macleod, Martin McKenna, Francesca Nobilucci, Joel Perez, Olga Rek, Derek Sutherland, Jessica Kirkpatrick, Paul Ditch, Joe Summerton and Hannah Rye.

Catalogue designed by Alisa Lindsay. Printed by 21 Colour.
Published in the United Kingdom by the Royal Scottish Academy of Art & Architecture
for the exhibition RSA New Contemporaries, 19 March - 13 April 2011
The Royal Scottish Academy of Art & Architecture
The Mound, Edininbrugh, EH2 2EL

The Royal Scottish Academy is a charity registered in Scotland (No. SC004198)
Cover image: Charlene Noble 'Sentimental' (Detail) 2010. Scanograph.

ISBN 978-0-905783-22-2